# Basic Camcorder Guide

*New Revised Edition!*

*Everything you need to know to get started & have fun! Packed with information— fully illustrated!*

**Steve Bryant**

Published by:

Amherst Media Inc.
418 Homecrest Dr.
Amherst, NY 14226
Phone:716-874-4450
Fax: 716-874-4508

Editor: Richard Lynch
Publisher: Craig Alesse
Copy editor: Rob Roberge

ISBN 0-936262-29-X
Library of Congress Catalog Card Number: 93-74836

Printed in the United States of America

# Table of Contents

## Section 2 — Getting to Know Your Camcorder

## Section 3 — Enjoying Your Camcorder

# Welcome to the World of Camcorders

Camcorders are one of the most entertaining pieces of home electronics available. With this marvelous piece of technology you become a movie maker, story teller, family historian, a theater owner...in fact, you will have fun just discovering the fascinating things you can do with your camcorder.

I have owned a camcorder for more than 10 years, going back to the days when camera and recorder were two separate units—my Quasimodo-type posture from those early days of lugging the "portable" VCR on one shoulder attests to the weight and awkwardness of those units. We're all much luckier today: most camcorders, especially the 8 millimeter models, weigh only a few pounds.

Today's camcorders virtually work themselves, and they're almost impossible to damage through normal use (I don't believe dropping one from a two or more story window is 'normal'). This makes using them a pleasure for the beginner and professional alike.

This book assumes nothing. It starts at **ground zero** and progresses in steps to give the reader a solid understanding of how camcorders work. Throughout you'll enjoy discovering the fun and interesting things you can do with your camcorder.

You can use this book as a powerful resource whether you're at home or "in the field." Carry it in your camcorder case. If you only use one idea from it every time you use your camcorder, your videos will look better and be more fun to watch.

This book will help you find the camcorder that's right for you and show you how easy it is to take better looking, more entertaining and interesting videos.

Did you know that:

- most camcorder owners ruin their videos by overusing the zoom?

- many people wind up weakening their camcorder batteries through misuse?

- a simple shooting technique can give your scenic shots a truly professional look?

- there are inexpensive items which can give your videos dramatic special effects without using fancy editing hardware?

- one item, packaged with most camcorders, can ruin your camcorder (not to mention your vacation) if used improperly?

- a device exists that allows you to make still "photos" from any videotape?

While you are learning the answers to these and other questions by reading this book, you'll learn how to have fun while shooting better videos.

Fun is the key! Have a blast with your camcorder and use it as often as possible.

Good shooting!

"...discover the fascinating things you can do with your camcorder."

# How to use this book

This revised edition of **Basic Camcorder Guide** is divided into three sections:

**Section One:** Choosing your camcorder.

**Section Two:** Getting to know your camcorder.

**Section Three:** Enjoying your camcorder.

Section One progresses slowly, allowing you to build a solid knowledge base about camcorders. Whether you are a beginner or experienced shooter, this section will help to make you much more comfortable about using today's camcorders.

Sections Two and Three are modular. You can use any of the points individually or in combination to improve your videos. I would suggest that you read both sections completely so you'll know all the techniques, then refer to them later to add to your bag of tricks. None of the ideas here are cast in concrete, but they provide a solid base to work from. Don't be afraid to use your own ideas and experiment with the ones here.

Refer to the Glossary whenever you encounter a video term you don't understand. There's also an Appendix which includes the names and addresses of companies that manufacture and distribute video accessories.

# Section 1

# Choosing Your Camcorder

Camcorder features and compatibilities

When you brought home that special date to meet your parents, remember how proud and excited you were? And remember how stupid you felt when they brought out those embarrassing photos of you in the nude on that bear rug? Now thanks to today's camcorders, you can do the same to your children, except that you can do it in full color video with hi-fi stereo sound.

In addition to embarrassing the socks off your kids, there is an endless list of fun, useful and educational things you can do with your camcorder. The first step is choosing the camcorder that's right for you.

This is really pretty simple. The three most popular camcorder formats are:

- **VHS.** Compatible with most home VCRs.

- **VHS-C.** Compact and compatible with your home VCR through the use of an adapter.

- **8 millimeter.** Compact, with the best image and sound quality of these formats, but not compatible with most home VCRs.

There are other formats you might consider if you think you'll be doing a great deal of editing. These additional formats (S-VHS, S-VHS-C, or Hi8), offer superior image quality, allowing you to make better looking copies and edits.

Which format is right for you? The following common sense recommendations will help you decide.

# VHS

## Home VCR compatibility

VHS camcorders are the largest and heaviest of the consumer market formats. While this might make for a steadier picture, it can be a pain in the neck (literally) for travelling. There are many excellent units on the market. The units made by Sharp and Panasonic are extremely impressive. Both are durable and offer some excellent features.

If compatibility with your home VCR is extremely important to you, and you plan to be a very casual user of your camcorder with few travel plans, VHS is a logical choice. Keep in mind that fewer VHS camcorders are being manufactured since 8 millimeter became the most popular camcorder format.

# VHS- C

## Compact, but still home VCR compatible

As the 'C' suggests this is a compact version of the VHS format—usually half the size and weight of regular VHS camcorders. The tapes are the same width as VHS, but the tape case is one-third smaller than full-sized VHS tapes. To play the VHS-C videos in your VCR, you must place them into an adapter that's usually included with the camcorder.

There are two drawbacks to VHS-C. If you want to send someone a tape, you will have to make a copy on regular VHS tape or send an adapter. An extra adapter will cost between $20 and $30. Also, the tapes play for a shorter time than regular VHS. If you travel a great deal and still want compatibility with your VCR, then VHS-C is a logical choice.

Panasonic and JVC make some of the best VHS-C units on the market. They offer many different models, a wide range of features, and reasonable prices.

# 8 Millimeter

## Superior quality, small size, and light weight

Once the rage of Europe and Asia, the excellent image and sound quality of this small, light camcorder, has made it the most popular format in this country as well. Because 8 millimeter uses a different size of tape, it will not be compatible with your VCR. You'll have to play back the tapes directly from the camcorder or get a dedicated 8 millimeter VCR.

The picture and sound quality of 8 millimeter is better than the VHS or VHS-C formats due to the different way the video signal is recorded on the tape. Sound is recorded digitally, similar to the way music is encoded on a compact disc.

This superior quality means that tapes copied from 8 millimeter to your VCR will be almost, if not just as good as, an original VHS tape from a VHS camcorder.

A docking unit is an easy way to keep your camcorder connected to a TV or VCR.

Sony and Yashica have come up with docking units for their 8 millimeter camcorders (I own one of the new Yashica docking models and absolutely love it). A docking unit plugs into your TV and stays plugged in at all times, just like a VCR. To play back an 8 millimeter tape on your TV, you simply snap your camcorder into the docking unit and play the tape in the camcorder.

While in the docking unit, the camcorder can record from your TV, making it an 8mm VCR. The camcorder battery also charges while it is in the docking unit.

Other excellent (non-docking) 8 millimeter camcorders are made by Canon, Fuji, Hitachi and Sanyo.

If you want superior picture and sound quality, don't mind hooking up cables for playback, and want a convenient, small camcorder, 8 millimeter is the format for you.

# Hi8 and Super VHS

## The very best quality

With even better quality video and sound than regular 8 millimeter camcorders, these semi-pro units raise the question, "How much is too much?" The picture quality output may be more than your TV can handle, and unless your TV is equipped with a special Hi8 or S-VHS input, you won't be able to take full advantage of the better picture.

Consider Hi8 and S-VHS if you plan to do extensive copying and editing. It's important to keep in mind that sometimes the Hi8 format is prone to occasional dropout, which is a momentary lapse of picture and sound. For this reason, many serious videographers prefer to use S-VHS over Hi8.

Both Hi8 and S-VHS use a more expensive type of videotape than the regular 8mm and VHS formats. However, almost all Hi8 and S-VHS machines will take regular VHS and 8mm video tape, automatically or at the flip of a switch.

If you think you will be doing a great deal of editing and/or getting a TV that has the special input required for either format, Hi8 or S-VHS might be right for you.

"...serious videographers prefer to use S-VHS over Hi8."

# Desirable Features

When you buy your camcorder, you'll probably be buried in the deluge of features, expressed in confusing technical terms that you don't understand. If you're anything like me, you won't question these terms, fearing it will show your ignorance. Hey, you probably don't ask directions either, and it only takes you an extra hour to drive anywhere you haven't been to before!

The following list of features should help. I've included features found on most camcorders, followed by a brief explanation. They are not listed in order of desirability, since that really depends on your exact needs. For that reason, I've included a brief application for each feature. Match your shooting needs with the appropriate features and you'll have a good idea of which camcorder is right for you.

**Autofocus**

Autofocus is the ability of a camcorder to focus automatically. There are three main types of autofocus systems: infrared, TTL (through the lens) and digital.

- *Infrared* was the first autofocus system used in camcorders. It will go in and out of focus, searching for the subject (or "hunt") more than the other two systems. Most camcorders using infrared focusing will be older technology and are often found as sale items at many stores.

- *TTL* autofocus systems are somewhat faster (meaning they will hunt less) than infrared systems. They are also better in low light situations than infrared.

- *Digital* autofocus systems will give you the fastest autofocus capabilities, regardless of lighting conditions.

The autofocus system on many of the better camcorders works in all focus ranges, including the macro settings. This enables you to go from an

extreme close-up to a telephoto shot without having to focus, and makes for much easier shooting.

## Lux

Lux rating is often misunderstood. Since a lower lux rating means that a camcorder can operate in lower light situations, you'd think a one lux camcorder would be better than a three lux. So did I until I discovered that there is no standard set by law for lux ratings. So who sets the lux standards? The companies themselves.

Although this area would seem fraught with possibilities of misleading advertising, the companies have done a pretty good job of policing themselves, even though a one lux camcorder from "Company A" doesn't equal a one lux unit from "Company B."

There are companies that advertise camcorders with capabilities of one-half lux (and lower), but there are practical limits. One lux is less illumination than what you'd get from a couple of candles. If a camcorder can take video with this little light, the image will be grainy and the colors will be washed out. For this reason, a color enhancement light (discussed later in this section) is a necessity for good quality videos in low-light situations, regardless of the lux rating of the camcorder.

While the use of extremely low-lux camcorders would seem to be limited to law enforcement surveillance (and voyeurs), you still want a unit with a fairly low lux rating. There will be times (especially indoors or outdoors at night) when a low-light camcorder will come in handy.

With the above said, many people think that a one lux camcorder from a manufacturer will work better in lower light situations than a three lux model from the same company. While this is usually true, there is one important exception. Most, if not all, camcorders manufactured today achieve their one lux or better rating through digital enhancement. Older camcorders (1989 or earlier) used larger diameter lenses to increase their lux, which produced a much sharper image in lower light. If you're going to be doing a great

deal of low-light shooting, you might want to seek out one of these older models. You may be able to find secondhand units, usually at very reasonable prices. Don't forget to ask how the low-lux capability is achieved.

One final lux note: Due to advances in video technology, a camcorder with a lux rating higher than three (from any manufacturer) is probably an older model.

A camcorder with a lux rating of 3 or less will allow you to get some dramatic shots in extremely low light situations.

## Zoom lens

A zoom lens allows you to close in on or fade away from your subject without moving. One rule: Get at least an 8:1 (read eight-to-one) optical zoom lens. The 8:1 ratio means that the maximum telephoto setting will be eight times closer than the widest angle view; 'optical' means that the zoom is controlled by the lens rather than the electronics. On the camcorder itself, 8:1 is typically labeled 8X.

There are camcorders on the market with digital (computerized) zoom lenses which exceed 64:1. These are fun to play with, although at over 16:1, they get fairly grainy. At 64:1, these digital lenses produce unrecognizable images—though they create an interesting mosaic effect that can add to your videos. A

powerful digital zoom is fine as long as the optical portion of the zoom is at least 8:1.

## Special effects

Many camcorders available today allow you to do some really exciting special effects. For example, dual lens camcorders allow you to put a picture-in-a-picture, or wipe (make a smooth transition from one picture to another) while you are shooting. One lens can take a close-up of a pitcher on a baseball team and superimpose it on a picture of the entire field taken with the other lens, or you can wipe from the delivery to the action on the field. Both effects are a little tricky, but they help you to create extremely interesting videos.

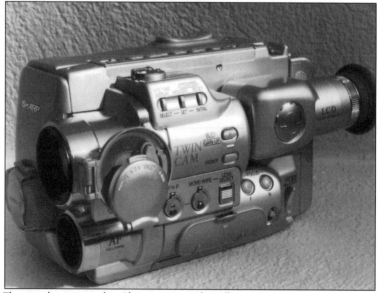

The two lenses on this Sharp camcorder allow you to create interesting special effects while you are shooting.

Some camcorders allow you create a strobe effect, where your video will flicker like an old movie. Others have built-in character generators that give you the ability to put titles on your videos. Keep in mind most camcorder-mounted character generators do a fine job, but are slow and cumbersome to use. If you really want to do some serious titling, get an external character generator (covered in "Editing Ideas," page 73).

Camcorders with new built-in special effects come out all the time. While all will add to your videos, you should find out how easy or difficult the effects are to access while you are shooting. If you like the effects and think you'll be able to use them with little or no trouble, go for it! Used sparingly (only when they will add emphasis to an important point), special effects will give your videos a more professional look.

**Shutter speed**

A camcorder doesn't have a mechanical shutter (a device that opens and closes to let light into the lens), but most camcorders have settings that allow you to control how quickly the light is processed.

Camcorder manufacturers measure this setting in still camera terms (i.e., 1/250, 1/1000, 1/10,000 of a second, etc). The faster the shutter speed, the better the camcorder will be able to capture fast action. This will be especially noticeable when you play back the videos and pause a section: higher shutter speed will give you a clearer still image of fast action.

Just like a still camera, the shutter speed adjustment on a camcorder allows you to get sharper images of fast action.

Keep in mind that, just like a still camera, you'll need more light to get a decent picture with a high shutter

speed. Most shutter speeds above 1/2000 will require bright sunlight or an extremely powerful (probably professional grade) external lighting source. If you are shooting a lot of outdoor fast action (as in most any outdoor sport), look for a camcorder with a top shutter speed of at least 1/4000.

## Wireless remote control

The one problem with being the family photographer or videographer is that *you* are never in the picture. If you're trying to keep an accurate family history, getting into the picture is nearly a necessity (*See* "Getting Yourself into the Picture," page 82). Some early camcorders, like some still cameras, tried to solve this problem with self-timers. You had to set the timer and hurry to get in front of the lens. With most units, you had to get out of the picture to turn the camcorder off. The solution was awkward at best.

Many of today's camcorders have wireless remote controls that let you turn them on and off, and control some of the features from 20 to 30 feet away. This not only gets you in the picture, but leaves you in control of the camera.

You have a better chance to "star" in your own videos by using a camcorder with a wireless remote control.

You will need a tripod to take advantage of the wireless remote. It's also a good idea to use a TV as a monitor for these situations. Just run a cable from the output of your camcorder to the TV's input, and place the TV so you will be able to see it from in front of the lens. This way you'll be able to see what's in the picture when you can't look through the camcorder viewfinder.

Remotes are also extremely useful for nature photography. For example, you can set up your camcorder next to a bird feeder and get striking shots of birds without frightening them away.

For your convenience, get a camcorder that has a storage compartment for the wireless remote. It's easier to keep track of that way.

**Color viewfinder**

Color viewfinders can be great, but make sure the camcorder was made no earlier than 1991. Prior to that, consumer-grade color viewfinders weren't sharp or bright enough to see in daylight. Today's camcorders, especially those from Hitachi, Sharp, Sony and Yashica, have excellent quality color viewfinders.

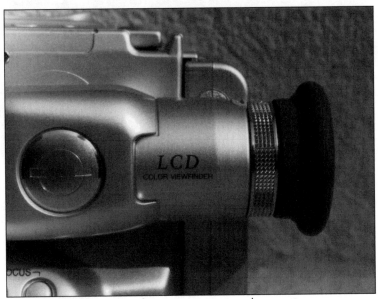

Color viewfinders can make composing your shots easier.

If you have an artistic eye, you'll find it easier to compose your shots when you're looking through a full color viewfinder. However, this is not an important enough issue for most folks to make a color viewfinder a necessity.

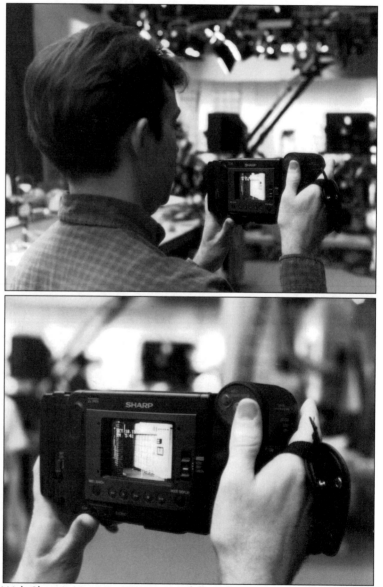

With Sharp's Viewcam™, you can follow the action on a 3" TV screen instead of a standard viewfinder.

## Switchable input/ output controls

Whether you're making copies of your videotapes, playing them back, or using your camcorder as a recording VCR, a switchable input/output control will make life a lot easier.

An input/output control allows you to use the same jacks (plugs) on your camcorder either to record or play. You can change from recording to playing back by using the switch located next to the jacks. A switchable input/output control cuts down on the weight and size of your camcorder, since one set of jacks does the job of two.

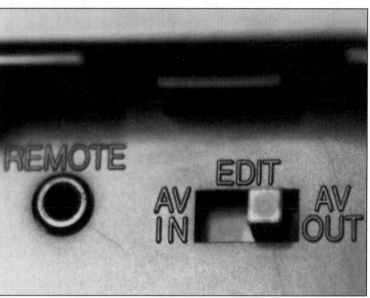

You can record and playback with a single set of cables if your camcorder has a switchable input/output control.

## Time lapse

Want to see the sun rise in 20 seconds, or watch a flower bloom in about the same time? Would you like to see that new addition to your home "come to life" and be built from start to finish in a few minutes? If so, then time lapse (also called 'interval recording') is for you.

A camcorder set on time lapse will usually take one second of video tape every 60 seconds. That means you will see 20 minutes of real time transpire in 20 seconds when you play the tape in your camcorder or VCR.

While you might use time lapse once in a while, it shouldn't be a major factor in choosing the camcorder that's right for you. Still, since it can add a great deal of visual variety to your videos, it's worth considering. You will need a tripod to effectively utilize this feature.

**Battery types**

There are three main types of batteries provided with most camcorders: NiCad (nickel-cadmium), lead acid, and lithium/ion.

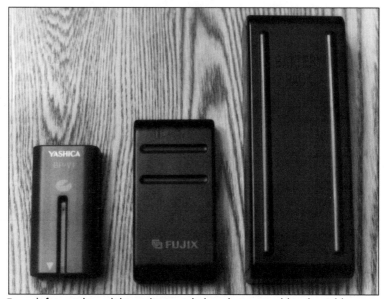

From left to right, a lithium/ion, nickel cadmium and lead acid battery.

■ *NiCad* are the most common type of battery. They do, however, have a memory problem: if you don't completely discharge them before recharging, they won't "remember" to keep a full charge. People who recharge their NiCad batteries after each use will find that soon the batteries won't maintain more than a few minutes of power.

For this reason, always completely discharge a NiCad battery before recharging it. The best way to do this is to use it until it runs out of power. Some camcorder manufacturers include refresher options on their NiCad rechargers. The refresher completely discharges the battery before recharging it, ensuring a maximum charge.

Many people who use NiCad batteries have a second battery. This way they don't miss any shooting opportunities when their first battery runs down.

■ *Lead acid* batteries are used by some manufacturers to avoid this memory problem. Lead acid can take a charge at any time, so you can constantly recharge them. They are heavier than NiCad cells and, with equal usage, don't last as long.

■ *Lithium/ion* batteries offer the best of both worlds. They have no memory problems, are lightweight, and have an excellent life span. If you don't want to be bothered by recharging restrictions, look for a camcorder with a lithium/ion battery.

Manufacturers are more frequently incorporating lithium/ion batteries into their newer camcorders. (*See* also "Battery Care," page 78).

**Image stabilization**

Image stabilization helps prevent video images from shaking when the camera does. Various stabilization systems have been around since the late 1980's. The early ones worked okay, but seriously degraded picture quality.

An Electronic Image Stabilization (EIS) system will help you to create steadier videos when walking or running to follow the action.

Today's stabilization systems are much better, especially the optical units from Sony (a technology licensed from Canon). These optical systems do not affect picture quality.

Electronic Image Stabilization (EIS) systems digitally process the picture to reduce shaking. However, even today's sophisticated EIS systems will result in some loss of resolution. The more current the EIS system, the less it will impact the video image. I've had great results with newer Hitachi camcorders that utilize EIS systems.

If you plan to move around a great deal when you're taking videos (following children, running to follow an athletic event or even walking down a path while shooting) then an EIS system may be right for you.

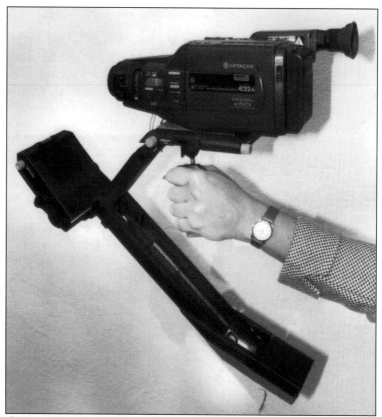

The Steadicam Jr.™ will professionally eliminate picture shake even when you're running up steps or on uneven terrain to follow the action.

An additional note: Remember the scene from the movie **Rocky** where the camera flawlessly followed the hero up the steps of the Philadelphia Art Museum? Now there's a steady cameraperson. Actually, it was filmed using a patented device called Steadicam™ that kept the camera perfectly level during the arduous climb.

The same company makes a model for camcorders called the Steadicam Jr.™ The unit attaches to your camcorder and keeps it perfectly level, regardless of how much you move. Videos made with the Steadicam Jr.™ are smooth and natural. If walking and/or running while you're shooting are important to you, check out a Steadicam Jr.™ at your local dealer.

## Flying erase head

Have you ever seen a video where the picture seemed to jump every time the camcorder stopped and started? The camcorder that took the video didn't have a flying erase head. A flying erase head erases a moment of video every time a camcorder begins to record. This ensures you of a smooth transition between scenes. Since all camcorders made in the last three or four years have flying erase heads, I won't waste a lot of time discussing it in detail. Simply stated, if the camcorder you are considering doesn't have a flying erase head, AVOID IT! The unit must be at least three years old, which is archaic technology in the world of video.

## Image sensor

An image sensor is the part of your camcorder that "sees" what you are shooting and transfers the image onto videotape. All current camcorders use at least one CCD (Charge-coupled device) chip as an image sensor. These are far superior to earlier technologies that included MOS (Metal Oxide Semiconductor) chips and tube-based image sensors.

# Sound Suggestions

**Stereo or mono sound?**

Stereo sound is better than monaural sound, right? Under certain circumstances, yes it is. But whether you get a stereo or mono camcorder depends on your needs.

First, the sound from a stereo camcorder will be completely compatible with a monaural TV and VCR. Likewise, the sound from a mono camcorder will be compatible with a stereo TV and VCR.

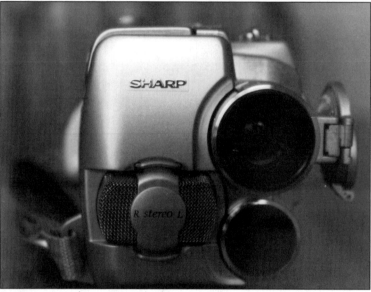

Stereo camcorders use two built-in microphones to record stereo sound.

A majority of today's camcorders are being made with stereo audio capability. In most cases, I would strongly suggest getting a stereo unit. The sound will be fine on your monaural TV, and if you upgrade to a stereo TV and/or VCR, you'll be ready.

However, if all you want is a low-cost unit to record a few family events, a monaural unit will be fine.

Finally, don't confuse hi-fi (high fidelity) with stereo. Hi-fi means that the unit can record and play back more low and high frequency sounds than machines not considered hi-fi. A stereo unit has two channels (left and right) of sound. A camcorder can be hi-fi without being stereo, although most stereo units are also hi-fi.

**Audio dubbing**

This topic is covered more completely in a section later in this text, but it is worth mentioning here. Most VHS, VHS-C, S-VHS and S-VHS-C camcorders can record a different audio track on an existing tape. If they can't, then you can do it with an external VCR, using the original video tape. VHS video and audio signals occupy different sections of the tape and can be used separately.

It's important to remember that the only 8mm or Hi8 camcorders that can record another audio track on an existing tape have PCM (Pulse Code Modulation) sound. PCM sound is a real plus if you plan to do a great deal of editing. If the camcorder uses AFM (Audio Frequency Modulation), you cannot record another audio track, because the video and audio signals occupy the same section of the tape and can not be separated. If you want to record another audio track (from your stereo, another microphone, etc.), you'll have to make a VHS or 8mm PCM copy of the tape first.

"A majority of today's camcorders are being made with stereo audio capability..."

# What's in a Brand Name?

While there are dozens of different camcorders on the market, there are actually fewer than a dozen manufacturers. Certain folks make camcorders for other companies; many times they simply place the other firm's brand name on the units they already produce.

This explains why many camcorders look alike. For example, Memorex Camcorders bear a striking resemblance to Sharp units. Sharp is an original equipment manufacturer (OEM) and just puts the Memorex name on its own units.

This is not something manufacturers do to put one over on the consumer. Not at all. High-tech companies often cooperate, sharing their expertise in particular areas. If a company has a product it's known for, it will manufacture units for another corporation that might offer the same service to them with other products in exchange.

You also might wonder if these "proprietary" camcorders are as good as the originals. I own a Yashica docking 8mm camcorder that, like all other Yashica camcorders, was manufactured by Sony. I love it! It's one of the most versatile and rugged camcorders I've ever owned. In fact, for some reason the Yashica unit hit the market before its Sony counterpart.

The bottom line is: don't get hung up on brand names. Most camcorders today are extremely high-quality units, regardless of who makes them. However, I have included the following table so you can see who makes what.

# Original Equipment Manufacturers

| OEMs | VHS & S-VHS | VHS-C & S-VHS-C | 8mm & Hi8 |
|---|---|---|---|
| Canon | | | Canon |
| Fuji | | | Fujix |
| Hitachi | Hitachi, Minolta, RCA | | Hitachi, Minolta, RCA |
| JVC | | JVC, Zenith | |
| Matsushita | Chinon, General Electric, Magnavox, Olympus, Panasonic, Quasar | Magnavox, Panasonic, Quasar | Chinon, General Electric, Magnavox |
| Minolta | | | Minolta |
| Mitsubishi | | Mitsubishi | |
| Samsung | Samsung | | Samsung |
| Sanyo | | | Fisher, Memorex, Olympus, Pentax, Sanyo |
| Sharp | Memorex, Sharp | | Sharp |
| Sony | | | Nikon, Ricoh, Sony, Yashica |

# Tape Quality

## Or lack thereof

Make sure the videotape you use is recommended by the manufacturer for camcorder use.

Put in the simplest terms, get the best brand of tape you can afford. Once you are satisfied with the results of a particular tape, stick with that brand.

Camcorders are very demanding on videotape—much more demanding than VCRs. The constant starting

and stopping that occurs when using a camcorder is extremely tough on videotape. Additionally, the almost infinite variety of shooting situations makes it imperative that you use the best tape possible to get the best color and clarity.

Instead of giving you a rundown of specific brands, I will just warn you about bargain tape. It stinks! All magnetic tape is coated with a metal oxide. Bargain tapes use inferior materials as well as shoddy production methods—this is how they keep the prices low. The oxide can easily flake off, ruining images, distorting sound quality, and making it necessary to clean your camcorder heads more often.

Any tape you use in your camcorder should be a major brand. I have a fondness for Maxell, Fuji, TDK and Sony. In most cases, good camcorder tape is labeled as "Special Occasion," "Library Grade," or given some other special designation. Although these labels are not industry standards, any tape from a major manufacturer targeted for archival storage or camcorder-specific use will yield good results.

A good 120 minute camcorder tape in either VHS, VHS-C or 8mm, should cost between $6.00 to $12.00—maybe a little less on sale. Never use tapes longer than a 120 tape in your camcorder. The motor in even the most expensive, high tech models may not pull it effectively.

S-VHS and Hi8 tapes tend to be relatively expensive. Good ones usually cost between $15.00 and $20.00.

"...get the best brand of tape you can afford."

# A Few Words About Television Sets

While TV shopping recently, I saw this great 25" name brand set on sale for about $300. The set had a fair picture: not great but watchable. The salesperson informed me that my choice only had a few hundred lines of resolution. He then recommended the Super Duper, 31", Mega-Stereo model, with enough lines to fill the state of Wyoming. He assured me this puppy would give me all the resolution available from my Hi8 camcorder.

Sure I could afford it...sort of. But being the enterprising, comparison shopper that I am, I left and came back with my camcorder. After plugging my camcorder into both, I could tell a little difference in the vibrancy of some colors, but that didn't justify the extra $1700 in my mind. Video is my hobby—a fun pastime, but not something that is worth this price.

The point: don't buy more TV than you really need. The human eye has limitations. Some TV sets have so many lines on the screen that they out-do the capabilities of our vision. The money you save on a television set can be used to buy a better camcorder or some other accessory goodies.

Those of you who keep up on technology might think you need to get a camcorder that is High Definition TV (HDTV) compatible. Put simply, don't worry about HDTV right now. I don't, and my life is richer for it. You should be concerned with having a great time shooting and watching your videos. Any technological change is going to be evolutionary, not revolutionary. We'll all have time to adapt.

# Section 2

# Getting to Know Your Camcorder

The basics for shooting excellent videos

## PICTURE QUALITY IDEAS

# Get a Steadier Picture with a Good Grip

The way you hold your camera is important for getting a steady picture. The cradle carry and bipod brace are two excellent, often used, styles of holding the camcorder that will help you keep the camera steady.

However you choose to carry your camcorder, keep both eyes open. It takes a little getting used to, but you'll have a better overall view of your subject as well as the terrain. This helps you to avoid little annoyances like walking into walls, off cliffs, into the path of an oncoming train...you get the idea.

**The cradle carry**

Most people carry their camcorders with the unit propped up on their shoulders. This can make for shaky video when walking, or for those who don't have very steady hands. Instead, try cradling your camcorder under your arm, much the same way you would with a portfolio style briefcase. Position the viewfinder so that you can look down into it. This will steady the camera, give a better viewing angle, and your videos will look better.

The cradle carry.

**The bipod brace**

Today's smaller camcorders invite you to use them with one hand. Put simply, don't. For a steadier grasp on these smaller camcorders, use your arms as a bipod. Grasp the camcorder firmly with both hands and then lock your elbows into your chest.

The first time I did this, it was surprisingly difficult. I was concentrating so hard on locking my arms into my chest that it looked more like I was performing some bizarre form of isometric exercise rather than trying to take great video.

Try to relax, and breathe normally. Use this technique for smoother videos with small camcorders.

The Bipod Brace helps to reduce image shake when you're shooting with smaller camcorders.

"Grasp
the camcorder
firmly with both
hands..."

# Zooming

Your zoom lens is a terrific tool that lets you get close to the action. Use the zoom feature when there's a reason to get closer to the action and zoom out when there's a reason to pull back from a subject and show the surrounding scenery.

Professional video and film cameras have tremendously powerful zoom lenses, yet they rarely zoom in or out when they're shooting a scene. You should follow this same guideline: in most cases, zoom in or out *before* starting to record.

Violate this rule (as do most camcorder owners) and your audience might experience a form of motion sickness.

"...zoom in or out before starting to record."

# Auto and Manual Focus

Moving subjects can "confuse " your camcorder's autofocus system. In some situations, it might be better to focus manually (*Top*: using auto-focus; *Bottom*: using manual focus).

Generally speaking, you will usually use the autofocus system on your camcorder. However, sometimes focusing manually will give you better videos. Most camcorders have a Auto/Manual focus switch. To focus in manual, you will either use the focusing ring or the zoom switch.

Manual focus is better any time your subject is moving rapidly or if there is a lot of motion in the viewfinder. For example, you would want to use manual focus at a sporting event or an air show. Many camcorders have an "infinity" setting in the manual mode. Infinity means that everything from a few feet out to as far as you can see will stay in focus.

When you have your camcorder set for autofocus and it can't seem to "decide" what and where to focus, this is known as *hunting*. It is prevalent on older machines, especially those with infrared focusing systems. To minimize hunting, start recording at the maximum telephoto setting then zoom out. All autofocus systems hunt less when they're zooming out as opposed to when they're zooming in.

One final point: If you want to shoot videos through a window, use manual focus unless your camcorder has an advanced digital autofocus system. Most other autofocus systems will focus on the first solid object they encounter—in this case, the glass. This means those shots of the Grand Tetons taken out the airplane window will show little more than excellent detail of the window frame. The blurred mountains beyond will look almost identical to the blurred city skyline you took on your last trip.

"...sometimes focusing manually will give you better videos."

# White Balance

You'll get the most accurate color on your videos by manually setting the white balance on your camcorder every time you change lighting conditions.

Colors can look different when lighting conditions vary (i.e., under sunlight, incandescent, or fluorescent light). White balance allows you to adjust your camcorder to produce the most accurate colors in different types of light.

White is not one color, but rather the combination of all colors. When you balance for white, in essence, you

are balancing for all colors. Anytime your light source changes (fluorescent to incandescent, indoor to outdoor, indoor to a combination of sunlight/indoor light, etc.) you should re-balance for white.

While most camcorders have automatic white balance, if you have one that allows you to do it manually, you'll have to do it yourself. It's pretty easy to do. Usually you simply hold a piece of white cardboard or paper in front of the lens while pressing the "White Balance" button (or the button designated in your instruction manual) and hold it down for about five seconds. Use the same piece of paper or cardboard for an entire shooting session to keep the same balance. Using the white balance properly will substantially improve color quality and accuracy.

"...adjust
your camcorder
to produce the most
accurate colors in
different types of
light."

# Backlight

## How and when to compensate

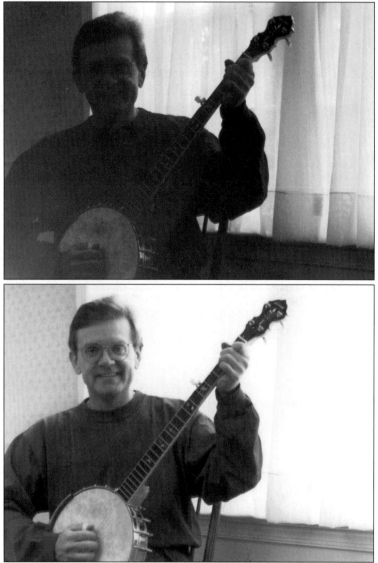

A bright light source behind your main subject will "fool" the aperture control on your camcorder, creating a dark image (top), unless you use the backlight control (bottom).

Using the backlight control lets you compensate for situations where a bright light source is behind your subject. Without using the backlight control, anything in front of the light source will look very dark and usually unrecognizable: your camcorder is reacting to the bright light in the scene and allowing less light to get to the videotape. The backlight control allows more light to get to your videotape, making everything look brighter.

Sometimes, the "shadowy" effect on your main subject will be desirable, especially if you are setting a mysterious or romantic mood (you rascal!). Rehearse the scene to make sure you're getting the lighting effect you want. If you like the darker image (silhouette) of your main subject, roll your tape. Otherwise, press the backlight button.

The backlight button is also extremely useful for taking videos when there's very little light, since the backlight button allows more light to get to your videotape.

"The backlight control allows more light to get to your videotape..."

# Depth of Field

What's in focus, and what's not

To increase depth of field (the range of what's in focus), use the maximum wide angle setting on your zoom lens. (At top *telephoto* zoom setting; at bottom, *wide angle* setting.)

Did you ever see a great photograph where the main subject was in sharp focus but the foreground and background were a soft blur? That photograph had very little depth of field. Conversely, a photo where foreground and background are clear has much greater depth of field. Controlling depth of field on your camcorder is a little tricky. But its visual impact on your videos is worth the effort.

Since you have little or no control of your aperture with most camcorders (*See* "Backlight," page 46), you are somewhat at the mercy of prevailing lighting conditions. As more light is available, more will be in focus in front of and behind your main subject. Less light means you will get less depth of field: fewer things in front of or behind your main subject will be in focus.

The setting of your zoom will also effect depth of field. The widest angle setting on your lens will yield the greatest depth of field; when you zoom in, depth of field will decrease. If you want the background to be in focus throughout a zoom, you will have to use a type of "manual zoom. Start out physically close to your subject using the maximum wide angle setting of your lens, and simply walk backwards. This will keep everything in focus from the start.

Depth of field can be a powerful creative tool for video. Play around with it in your next video. You'll soon realize the different moods you can create by changing what's in focus and what's not.

"Depth of field can be a powerful creative tool for video."

# Framing

## Using obstructions to your advantage

Zooming in or out through a natural "frame" can add to your videos.

I'm sure you've noticed that a framing and matting can add a great deal of pizazz to a photo, poster or painting. These techniques can also add a great deal to video.

You can use doorways, window frames, or natural elements like trees or mountains to frame whatever you're shooting. It's an excellent way to draw attention to your main subject.

One nice application for this would be a video of a child taken through a window frame over a period of years (age one, two, three, etc.). Since the window will always be the same size and won't change much over time, the growth of the child through the years will be quite evident, and you'll have a very visual record of their "meteoric" growth. Open the window if your autofocus system won't work through glass.

"[framing] is an excellent way to draw attention to your main subject."

# Panning

## For golden results

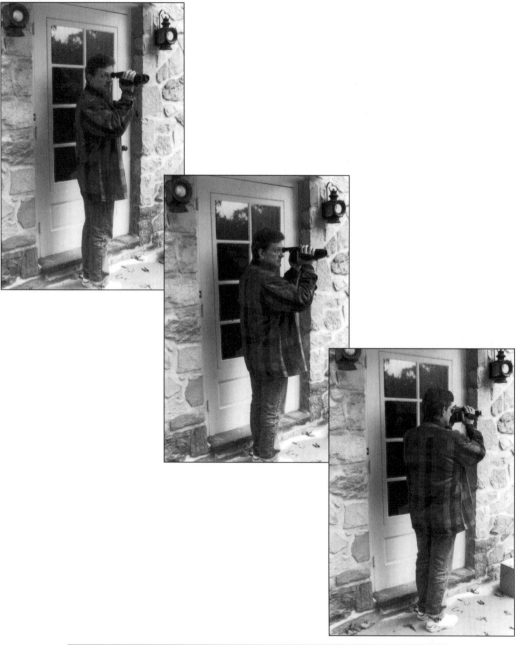

The cameraperson's feet should point in direction where a pan will end.

Moving your camcorder across a scene to show a panoramic view is called panning. It's an excellent way to follow action. It can get awkward, however, when you turn your body completely from one side to another and find yourself off balance—and that you'll have to stay that way to continue to shoot.

If you know which way your subject is heading, position your feet in that direction and turn your body back to face your subject without shifting the position of your feet. When your subject moves, your body will "straighten out" as you follow the action. This will increase your balance help to keep your videos smooth and steady.

This maneuver will also keep you from falling on your keister. Though you may only suffer a blow to your ego, there are no minor or inexpensive camcorder falls.

A tripod can make your life much easier. Very smooth pans can be easily accomplished with a tripod, especially those with fluid heads (*See* "Tripods and Monopods," page 60).

"...there are no minor or inexpensive camcorder falls."

# Tilting

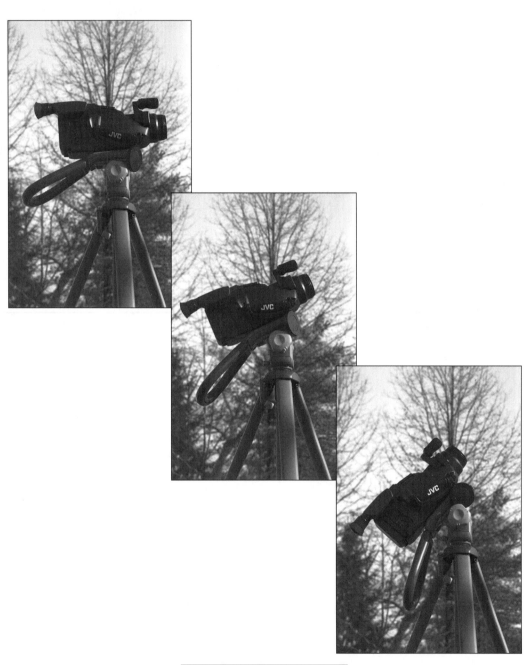

The vertical version of panning.

The vertical version of panning is called tilting. It is an excellent way to convey size.

Tilting down, especially from a high place, can express an exaggerated feeling of height and/or distance. This feeling can be enhanced by starting the shot on the maximum zoom setting and then pulling out while you tilt down. For example, this type of shot could heighten the drama of a video shot from the top of the Empire State Building, tilting down to reveal the Manhattan cityscape.

To make your tilts easier, you will want to move in the direction of the tilt. Step slightly forward with one foot as you are tilting upward, and step slightly backward with one foot to tilt downward. As with panning, a tripod with a fluid head will make life much easier.

"...express an exaggerated feeling of height and/or distance."

# Composition

### Using the rule of thirds

Good composition can strengthen your videos. In almost any good photograph, the main subject is rarely smack dab in the center. This is because most good photographers compose their photos using the rule of thirds. This rule uses imaginary lines to divide a photo into equal horizontal and vertical thirds.

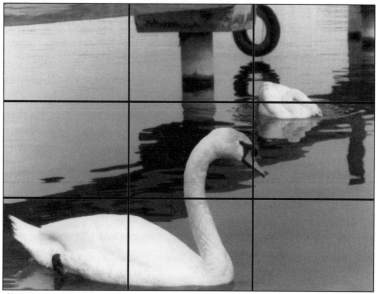

The swan is positioned near the intersection of the lower left third lines.

The intersections of the lines are the most aesthetically pleasing places to locate the main subject. However, autofocus camcorders pose an interesting problem: since the autofocus zones on most camcorders are located in the center of the frame, you will have to use manual focus (**See** "Auto and Manual Focus," page 42).

Sure it's a little more work, but focusing manually allows you to put the main subject anywhere you want. You don't have to do it all the time, but seeing little Jane and Johnny somewhere other than the middle of the screen every once in a while will give a nice bit of variety to your videos.

**Shooting scenery like a pro**

A wonderful country lane will look even nicer if you shoot it on a diagonal. A diagonal shot of a road, shoreline, tall building or any similar object will balance your frame. A straight on shot will detract from the aesthetic balance of your shot.

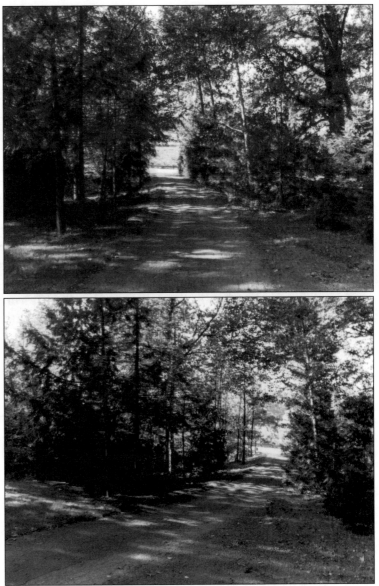

Many times, shooting "across" a scene (bottom) will give you a more pleasing image than shooting it "straight on" (top).

# The 180° Rule

## Avoid confusing shots by not crossing the line

Television stations always shoot video of football games from one side of the field. They never change sides in the middle of the game, unless they identify the shot as a reverse angle during an instant replay. This is no accident: they purposely never cross an imaginary line that runs through the playing field in order to keep the viewer oriented. You should keep this in mind as you take your home videos.

For example, if you're shooting a family event in your back yard, try to take all your wide angle shots using the same background. If the background remains the same, the viewer will always know what they are looking at. Your backyard might have a few trees, perhaps a fence, and looking back toward your house, you will probably just see an outside wall, some windows, and a door: two completely different backgrounds. If you switch these backgrounds without careful narration, changing shots can confuse the viewer—the shots might seem edited together from different events, or the action might seem incongruous.

If you want to cross the 180° line, simply keep the camcorder rolling while you walk from one side to another. This will let the viewer experience, or see, the shift in perspective. Use the cradle carry or the bipod brace technique to minimize camcorder movement as you walk.

# Eyelines

Allow a little more room on the side of the shot corresponding to your subject's eyeline.

Leaving space in the frame for your subject's eyeline is a simple idea that can add a real professional touch to your video productions. Whenever someone looks off to one side or another, make sure that he or she has somewhere to look. It seems a lot more logical, visually, if your subject isn't looking right off screen.

Since most of your videos will be candid and totally unplanned, you might shoot a subject who arbitrarily looks off the frame. In these cases, pull back to a wider angle view to give your subject room. Since there is a reason to use the zoom lens in this situation, the zoom will look natural and professional. Try to zoom slowly and evenly.

## ACCESSORY IDEAS

# Tripods and Monopods

"Shake, Rattle and Roll" was a great tune, but it's a lousy philosophy for taking pictures with a camcorder. A tripod or monopod (which has one leg rather than three) will make your videos steadier. A tripod can help you rest your weary bones when taking marathon videos of sporting events, plays or other long events. It's a necessity when using the time lapse, wireless remote control, and/or self-timer on your camcorder.

You want a solid tripod, one that is sturdier than those used for still cameras, as even a tiny 8mm camcorder can outweigh a 35mm single-lens reflex camera. A heavy tripod may be a little more inconvenient to carry, but it will help keep you from having to watch your camcorder topple over, as it might on a flimsy tripod (this usually happens when you are too far away to do anything but gasp).

To make sure that even a sturdy tripod doesn't take a "header" in a stiff breeze, hang a sand bag or other weight from the center of the tripod to make it more stable. Check with your local photo dealer for the correct method of doing this with your particular tripod.

If you don't want to carry a substantial tripod, a smaller monopod may be the answer. Since it only has one leg, the unit can be much lighter and mobile

than its bulkier three-legged cousin. A monopod is great for fast action sports, such as basketball, soccer, tennis, horse and auto racing, or air shows.

The mounting section of a tripod is called the head. When you move your camcorder up and down (tilting) or from side to side (panning), the resistance of the head helps to make these moves smooth.

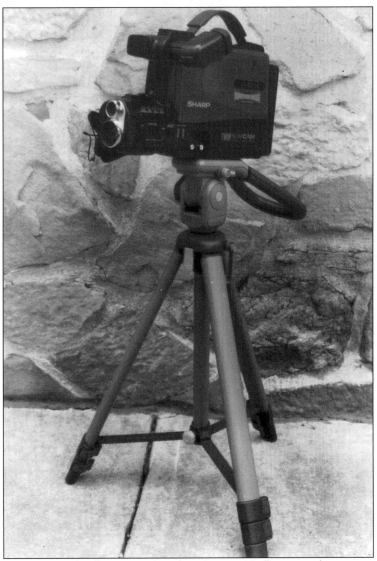

Using a tripod will give you steadier shots, as well as smoother pans and tilts.

Tripods are available with two types of heads: friction heads and fluid heads. Friction heads are less expensive. They create resistance by metal rubbing against metal. They're not bad, but a fluid head is better for making smoother movements.

The head on a fluid head tripod floats on a bed of oil or other fluid. This makes for very smooth moves, but is somewhat more expensive than the friction variety. There are also tripods with fluid *effect* heads. These give you results which are nearly as good as fluid heads for less money than a true fluid head tripod.

A list of tripod manufacturers appears in the appendix of this book. The Steadicam Jr.™ is another steadying device (**See** page 28).

"A monopod
is great for fast
action sports, such
as basketball,
soccer, tennis..."

# Color Enhancement Light

In low light, you'll get better images with a color enhancement light.

A color enhancement light will help you get a good picture in low-light situations. On most camcorders, it mounts to a bracket, or shoe, directly on the camera. On other models (usually older), it must be attached with an external bracket.

The color enhancement light is sometimes powered by the camcorder's main battery. The battery drain from this type of light is enormous. Your battery will only supply about half of your normal recording time if it must power a color enhancement light, as well.

Some color enhancement lights have their own rechargeable battery. These are excellent, as they allow you to use your light without costing you any recording time. If you get one of these, make sure it's at least five to ten watts.

# Filters

## For special effects and protection

Above, a star filter is used to create a multi-pointed "star" effect.

A filter is a piece of optical glass or plastic that's placed over a camera lens to alter images. You can get vivid colors and/or some great special effects with little effort by using one or more filters.

Some filters attach individually to the lens of your camcorder. I prefer the system approach, where you screw a filter holder on your camcorder lens and then simply snap in the filters you want. A great system is made by Cokin (**See** Appendix).

There are literally hundreds of different filters available, and you may want to check with your local photo or video dealer for more information. The following list includes those that can be most useful for video:

■ *A color enhancement filter* will give you more vivid colors in any lighting situation.

- *A star filter* will create one or more starburst effects on your videos.

- *A vignette filter* can create a soft, romantic effect.

- *A multiple image filter* will multiply subject images and create some wild special effects.

- *A neutral density filter (ND)* is useful in high contrast situations, such as skiing shots in bright sunlight or shots on the water. ND filters cut down the overall amount of light to the camcorder without darkening the subject.

- *A polarizing filter* can also help in high contrast. It's a two-part filter which can be adjusted to remove glare from shots taken in bright sunlight.

- *A skylight or UV filter* is an important addition to your camcorder lens. Although they will give you a slightly better image when shooting outdoors, you should always use one of these for lens protection. After all, what would you rather scratch, a $10 filter or a several hundred dollar camcorder lens? The filter acts as your ounce of prevention.

A few of the  protective and special effect filters available for your camcorder.

# Safety Strap

Keep a grip on your camcorder, even when using a safety strap.

Don't call it a carrying strap! It's a *safety* strap! It's a *safety* strap! It's a *safety* strap! I have seen vacations ruined by someone relying on that one dollar's worth of cloth to carry a $1000+ camcorder. Listening to your camcorder bounce down the stairs on a cruise ship is one of the worst sounds you will ever hear— but it may well happen if you trust this cheesy thing to hold your camcorder. Only use the safety strap as insurance should you ever loose your grip. 'Nuff said!

# Making Photos into Video and Vice Versa

**Video transfer units**

Your friends thought your new video hobby would spare them from an endless stream of photos, slides and home movies when they came to visit. Little did they know there's a device called a video transfer unit that helps you put your photos, slides and movies on videotape.

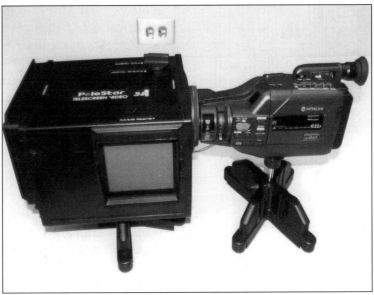

Video transfer units let you videotape still photos, slides and movies.

The unit is simple: you set up your camcorder, and put a photo in the transfer unit. Simply turn on the camcorder for a few seconds and *viola!* You've transferred the photo onto tape. You can zoom in or out to add a little movement. It is a little labor-intensive, since you have to start and stop the camcorder and change photos, but the results can be rewarding.

The same transfer unit can work for slides and movies. Most have a mirrored section where you focus a movie or slide projector. With movies, you just let the projector and camcorder run. For slides, you'll get the best results by stopping your camcorder between each shot. This eliminates the transition movement that occurs between slides.

Transfer units can cost substantially less than $100. There are more involved true film chains, where a movie or slide transfer is accomplished by a series of precision lenses and mirrors. The quality is better, but these devices are much more expensive than the simple video transfer units, and might not be worth the extra investment to you.

## Video printers

A video printer allows you to make still prints of any paused section of a videotape, effectively combining still and video photography. For the best results from a video printer, your camcorder must have a noise-free still picture ('noise' refers to the bands of static that can appear on the top and bottom of a video image).

While not nearly the quality of a photo enlargement, video prints offer you an opportunity to have a nice "photographic" memento of those times when no still camera was available. For example, you could make a print from a vacation or family video, frame it and put it on your desk. They're also nice to send to people who don't have VCRs—a way to share memories without making a full copy of a videotape.

"...make still prints of any paused section of a videotape..."

# Sound Accessories

**Built-in vs. external microphone**

Appearances to the contrary, this is not the title of the latest Godzilla movie. Seriously though, the built-in microphone in your camcorder will do a fine job for most ordinary shooting situations. However, since it is mounted on your camcorder, it will pick up some unwanted noise from the camcorder and transports.

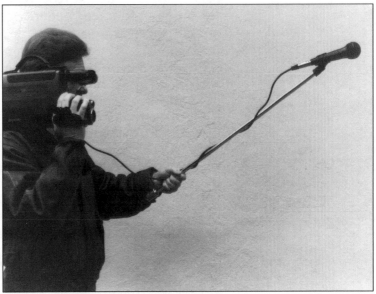

External microphones can improve sound quality in your videos.

The extraneous noise built-in microphones pick up will be particularly noticeable when you are trying to record sound-sensitive events like concerts, plays, and speeches. For these occasions, you'll want to purchase and use an external microphone. Before buying, be sure your camcorder has a jack for an external microphone. Then check your instruction manual to find the impedance requirements, usually listed in the manual with the rest of the technical specifications. It's a good idea to take the manual with you when you go shopping.

If your local photo or video dealer doesn't have a good external mike, check the local music store. You can

expect to pay at least $50 for a good name brand. I've had excellent results using microphones from Electrovoice, Sennheiser, Schriber Acoustic, and Shure.

Microphones can be hardwired, meaning that they are connected to your camcorder via a wire or cable. There are also wireless microphones on the market, which are particularly useful if you are shooting in a situation where a wire might cause tripping, tangling, or tugging. A small receiver unit plugs into your camcorder while your subject wears a miniature transmitter. Audio-Technica, Azden and Nady make excellent quality wireless equipment. Prices for wireless microphones start at over $100 and can run to well over $500 for a unit featuring professional quality and extended range.

Nady also makes a headset microphone that's great for recording narration while you shoot.

## Eliminating Wind Noise

Although the eerie sound created by the wind can add a lot to a monster movie, it doesn't do diddly for your video of baby's first step. For years, I have carried a thin sock in my video bag to place over the camcorder microphone whenever the wind is howling.

A sock attached over a microphone to limit wind noise.

Unfortunately, using the **Bryant Foot Warmer/Wind Noise Limiter** will also cut the overall volume as well. Keep this in mind: the thinner the sock, the better the sound—a little wind noise through a thin sock is better than baby's first word sounding like muffled Pig Latin.

Some camcorders have a digital wind-noise eliminater feature. Although having a partial argyle adorning your camcorder's microphone is a great conversation starter, this feature eliminates the need for the sock.

## Adding custom soundtracks

Most camcorders have sound inputs that allow you to dub (record) sound onto an existing video. To make this type of audio dub, you need to connect the camcorder input to the line outputs of your stereo system, tape player, or CD. Many newer camcorders allow you to mix (combine) the new sound with the original soundtrack.

You can add music to your videos with a cassette deck, CD player, or turntable.

However, be careful when dubbing: on some machines, dubbing new sound will *completely* replace the original track. Check your owner's manual before you accidentally wipe out an important soundtrack. [**Note to 8mm users:** on camcorders with

AFM (Audio Frequency Modulation) sound, trying to dub new sound will completely erase both the audio and video portion of the tape. Check your owner's manual to find out which system your camcorder uses].

A mixer can help you better control the quality of your mixes. These devices range from the very simple to the extremely complex, and the complexity is usually directly related to the number of channels. A two channel mixer will allow you to mix sound from two sources (or left and right stereo), a four channel mixes sound from four sources, etc.

Even though you could get up and running with two channels, get at least a four channel mixer. The extra two channels don't add that much to the cost, and chances are if you start adding music, sound effects and additional narration to your videos, you'll need more than two channels.

Sound source cables are connected to the input of your mixer while the mixer output is connected to the recording video unit (VCR or another camcorder). The mixer controls which allow you to create the proper balance between the different sound sources.

Azden, Nady, Panasonic, and Tascam are some reliable names to look for in the world of mixers. Some units mix audio and video signals simultaneously (*See* page 74).

"Editing puts you in control!"

## EDITING IDEAS

# Basic Editing

Say you just shot two hours of video at your family reunion. Try to show that tape in its entirety and you'll send even the most stalwart family member right over the edge. Get a reputation for these kind of boring presentations and you start hearing excuses like, "Gee, I'd love to see your home videos, but I really should schedule that liver transplant I've been putting off for so long."

The solution? Make shorter, more interesting videos by assembling the best shots in an order that makes sense. This process is called editing.

Editing puts you in control! It lets you tell your story your way by putting the scenes in any order you want. There are many different ways to edit. Below are some of the most effective, listed in order from the simplest to the most complex.

**Machine-to-machine editing with a VCR**

Plug the video and audio outputs of your camcorder into the video and audio inputs of the VCR. Let your camcorder run as you start and stop the VCR, catching the most interesting and/or entertaining moments. If you can, use the "pause" control on the VCR as it will make quicker starts and stops than using the "stop" control. Most recent VCRs (four heads or better) will have the capability of making clean transitions between edits.

If you try this and are not satisfied with the quality of the transitions, reverse the process: connect the video and audio outputs of your camcorder to the video and

audio inputs of your camcorder. Play the tape on the VCR and start and stop the camcorder (using the pause control).

Try both machine-to-machine techniques to see which gives you better quality copies.

Simple edit set-up from camcorder to camcorder.

**Editing consoles and video controllers**

Editing consoles and controllers are units that help control the editing process. They can help add some element of pizazz to your presentations. Some allow you to fade in or out between scenes, perform wipes, add titles and graphics, mix sound, enhance color, and sometimes much more.

Like automobiles, there are Hyundais, Rolls Royces and everything in between. A stand-alone editing unit can cost as little as $50 for a simple unit up to as much as several thousand dollars. Rather than make specific recommendations, figure out what you want to do and discuss your needs with your video dealer.

In most cases, the salesperson will probably recommend a basic video editor to get you started. Then, if you really want, you can upgrade as your experiences, interests, and needs change.

A video editor such as this allows effective editing with a camcorder and VCR, two camcorders or two VCRs.

**Desktop video**

Desktop video is a perfect marriage between your personal computer and your camcorder. There are many terrific software packages on the market that allow you to explore the current limits of video editing.

With the proper software, your home computer can help you to create professionally edited videos.

Animations, network-quality graphics, special effects that would make George Lucas proud: all these and more are possible with desktop video.

Like editing consoles and controllers, there is quite a variety of systems and prices. Software systems will allow you to use any existing PC (Amiga, Apple or IBM). Some of the entry level systems start at about $200, but the more advanced systems can cost a few thousand dollars. Many times, this higher cost is for advanced video processing boards for your computer which are necessary to take advantage of program capabilities.

Video work stations (complete hardware/software system packages) are also available, the most famous being the Video Toaster. A good "Toaster" system will cost you between $4000 and $8000 (with all the "bells and whistles"). However, if you want to edit like the pros, Video Toaster is the way to go.

"...if you want to edit like the pros, Video Toaster is the way to go."

# MAINTENANCE IDEAS

# Head Cleaning

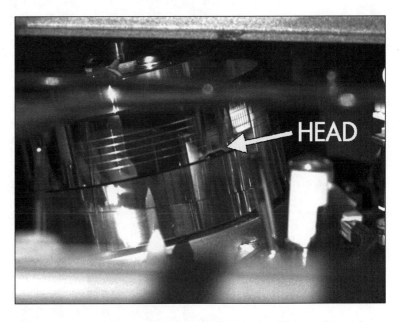

If you use your camcorder often, you'll need to clean the record and playback heads at least a few times a year. There are some fine head cleaning tapes on the market. Your dealer can recommend one that's right for your machine. These tapes run in your camcorder for a few minutes while cleaning the heads.

Even if you use cleaning tapes on a regular basis, you should have a professional clean your camcorder once a year. Depending on where you live, this will cost between $25 and $50. But, considering how much longer and better your unit will work, it's definitely worth the investment.

# Battery Care

Many camcorders use NiCad (nickel cadmium) batteries, which are are susceptible to memory problems (*See* page 26). Always allow NiCad batteries to discharge completely before recharging. If you find your battery is holding less power between charges, consider buying a separate recharger/refresher unit.

Lead Acid and the newer Lithium/Ion batteries can be recharged at any time. Independent manufacturers make replacement lead acid or lithium/ion batteries for camcorders with older NiCad cells, some of these with extended life (twice the recording time). Before buying, make sure you're not violating your camcorder warranty by using a battery from a third party.

Rechargeable batteries can lose one-percent of their power every day they're out of the recharger. For that reason, keep your batteries in a recharger when not in use, and your camcorder will always be ready to go. You can't overcharge most batteries, but check your instruction book to be sure.

When not in use, keep your battery in a recharger.

# Section 3

# Enjoying Your Camcorder

Shoot better, more interesting videos with advanced techniques

# Getting Better All The Time

## How to improve your videos painlessly

You can take better videos each time you shoot by examining your results. The better your videos are, the more satisfying they will be for everyone who watches them—and this adds up to more fun and satisfaction for you.

Every time you look at one of your video tapes for the first time, be your own critic. This will make your own shooting trends easy to identify and improve. Try keeping a written log of your favorite videos, detailing what you liked, and what you didn't. For example, think about how a particular scene might have been shot by your favorite film director. Don't overdue it; this should be fun.

It is also important to self-criticize in a positive vein: don't think things like, "I can't believe how terrible this part is;" instead, ask yourself, "how could I make this a better video?" Try asking yourself these questions, as well:

- Which different camera angles would be better for a particular shot?

- Is there another zoom setting that could have made the shot more enjoyable for the viewer?

- Would a creative filter have made the scene more enjoyable?

Again, have a blast! You're making instant home movies with equipment that dwarfs the technology used on classics like *Gone With The Wind* and *The Ten Commandments*—the possibilities are literally endless!

# Great Kid and Pet Videos

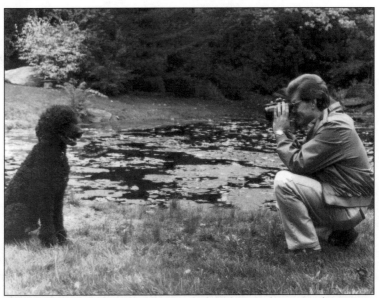

For more enjoyable and interesting kid and pet videos, get down on their level.

Almost everyone who takes video (or still pictures) of kids and pets stands while taking them, looking down on the subject. The best views of children and animals are those taken at their level. Don't be afraid to get down on one knee or even in a fully prone position the next time you take videos of kids and pets.

Children and animals take on a new importance when you video them on their level. Conversely, if you want to convey a sense of size and grandeur with a large animal like a horse or elephant, shoot it looking up. This "upward" view will exaggerate the size and heighten the impact of larger creatures.

# Getting Yourself into the Picture

## Teach others how to use your camcorder

Teaching friends and family members how to operate your camcorder will help everyone to enjoy it more. Having another videographer handy is also a good way to get yourself into the picture—better than using a self timer or remote control.

I can hear those objections: "People are afraid to use my camcorder. They're afraid they'll take stupid shots or even break it." But isn't that how you felt the first time you used your camcorder? And remember how exhilarated you felt when your first shots looked pretty good?

In introducing someone to your camcorder, make them feel comfortable. Communicate the excitement inherent in using it. Tell your budding videographer that the unit almost works by itself. Show them the record button, and demonstrate its simple operation. Explain that the unit is autofocus and even automatically adjusts the sound level.

Most importantly, guide your student gently through the use of your camcorder. Once they grasp the use of the record button, talk to them about the zoom lens, adding to their knowledge one feature at a time. Remember, you didn't learn all the nuances overnight. It's easy and fun for you to use your camcorder, and you can make using it just as simple and enjoyable for anyone who will try. And you'll get to be part of the picture.

# Videotaping Your Valuables

Include brand names and serial numbers in macro shots of your valuables.

The macro focus feature on most camcorders will allow you to get great close-up shots of your treasures. If you are burglarized, a videotape of your possessions will be extremely useful for insurance purposes. With most units, setting the lens to the maximum wide angle position allows you to take shots one inch from the lens or closer. Auto macro focus, found on many camcorders, will make your life much easier.

It's helpful to write or generate a title telling what each valuable is, its cost and serial number (use a mirror to videotape your camcorder). Narrate this information while you are taking the video. Put this tape in a safe deposit box or some other secure place.

Don't skip taping your valuables thinking this won't happen to you. Statistics show that one in four houses is burglarized.

# Sports Videos

You can shoot any sporting event like a pro.

Your sports videos might never make ESPN, but you still want them to be as professional looking as possible. Here are five tips for professional results:

**1.** *Anticipate the action.* Know where a person or object is going. If it's a situation where you'll be panning (and most times it will be), make sure you adhere to the panning guidelines (**See** page 52).

**2.** *Watch the pros.* When watching sporting events, notice how the major networks cover the event and then copy their technique. Remember that they're probably using a dozen or more cameras, so you won't be able to imitate exactly. Instead, pick out the two or three most used angles for your particular sport, and take most of your video from those vantage points.

**3.** *Start tight (video talk for close) and pull back as the action unfolds.* For example, start shooting a football play with a tight shot of the center and

quarterback. Pull back as the ball is snapped. Once you know who is going to carry the ball, zoom in on that player. Next time you see a football game on television, you'll recognize this as a commonly used technique. Check out TV coverage of other sports for more ideas.

**4.** *Get crowd reaction shots.* A cheering (or booing) crowd will add a great deal of authenticity to your sports videos.

**5.** *Narrate the action.* Even though you might feel a little awkward doing it, a live narration can add a lot of "punch" to your presentation. This is especially true if your child or someone else you know is in the game. A personal touch like this can be priceless.

"Anticipate the action."

# Making Money with Your Camcorder

## Or at least breaking even

A few years ago, you could own one camcorder and make a nice piece of change recording weddings, parties, and other events. Today, this is tricky because many experienced wedding planners and DJs offer this service. But there are still some options for the business minded camcorder owner:

1. *Insurance.* Offer services to make video records of valuables for insurance purposes. There are lots of people with valuable jewelry and collectibles who don't own camcorders. Try a small ad in the local paper. Have a lawyer draw up an agreement form that absolves you of any and all liability.

2. *Small parties.* You might not make a fortune, but simple, one camera productions can make you some money. Be sure your customer understands that the video will be a simple filming of the affair.

3. *Local news.* Like weddings, this is very tricky business. Even if you get lucky and happen to be on the scene of breaking news, local TV stations and the networks will pay very little for amateur news videos. If you have incredible footage of a major news event, the tape could be worth some money.

4. *Video lectures.* If you take the time to create a nicely edited piece on a scenic location (the Grand Canyon, for instance), you could charge for the presentation. Local groups, fraternal organizations,

libraries, and so on, are always looking for interesting presentations. With the right subject, you could give the same talk dozens (if not hundreds) of times to different groups. Make sure that the groups you rent to have their own playback equipment; your profit margin and motivation can fade quickly if you have to provide (and transport) a large screen TV or video projector and VCR.

"...some options for the business minded camcorder owners."

# Weddings

Your "amateur" video can capture behind-the-scenes wedding excitement.

First and foremost, strive to tell a story when making a wedding video. Before the big day, make a shot list of all the events that would tell a complete stranger what happened. Remember you are shooting *moving* pictures: always plan to capture action and movement, leaving sedentary shots for still photographers.

Start with the bride and bridesmaids getting ready, then move to the church while family and friends are arriving. The classic shot of the bride coming up the aisle is vital as is the kiss at the end of the ceremony. This might be followed by the greeting line at the back of the church and the obligatory rice-throwing.

At the reception, shoot the arrival of the bride and groom and at least one of their many public kisses. Follow this with the cutting the cake, tossing the bouquet and the garter ritual. The bride's dance with her father and her first dance with the groom are great video opportunities. Don't forget to shoot the departure, especially if their car has been "customized" with tin cans and the like.

Shoot more video than you need: you never know when a once-in-a-lifetime shot is going to present itself. (I once missed my Uncle George dancing up a storm while wearing the bride's veil. He passed out before I got my camcorder ready.) Don't worry about your tape being too long, as you can always edit it down to a respectable length later (*See* "Editing Ideas," page 73).

Nowadays, most people who professionally videotape weddings have at least two cameras and a great deal of editing equipment. In most cases, your attempt at making a wedding video will be a one-camera shoot with minimal editing. While this makes a nice wedding gift, charging for amateur production is probably not a good idea. After all, if the participants aren't happy, it's not likely that they will restage the event (Mickey Rooney and Elizabeth Taylor notwithstanding).

Give the bride and groom your original or an edited version of the tape. This is a very special, personalized gift. If you are a parent, grandparent or close friend of the bride or groom, you might consider taking video of the wedding and giving the tape and camcorder to the bride and groom as your gift. Make sure you give them all the accessories, paperwork and maybe even another fully-charged battery. A copy of this book wouldn't be a bad idea either.

# Words of Warning About Videotaping Weddings

There's nothing worse at a wedding than someone with a camcorder getting in everyone's face. (Okay, maybe a food fight at the reception would be a little worse.) You can have a great time and get some terrific video footage if you follow a few simple guidelines.

Ask permission from the church, synagogue, mosque or any other religious sanctuary you may be taking the video in! Usually the clergyperson will have no problem with you videotaping the ceremony as long as you don't disrupt the proceedings. Since the lower light in most churches will create a wonderfully romantic mood, don't use a color enhancement light. Think about what a bummer it would be if the bride tripped and fell flat on her veil after being blinded by *your* video light.

If there's a professional videographer at the wedding, don't get in the way! Don't get the same shots the pro will: use your knowledge of friends and family to take video of what a professional might miss. At most weddings, you'll know many of the guests, and you will probably know how to get some touching and funny shots that a stranger might miss. (I always shoot the "Alley Cat" dance at the reception, waiting for someone to have a coronary when the band hits full speed.)

"...use your knowledge of friends and family to take video of what a professional might miss."

# Astrovideography

No special hardware is required to take video through a telescope.

You can take great videos through your telescope without any special hardware. Using the telescope's lowest power eyepiece, focus on your subject. I've found that since the moon is the largest and brightest "target" in the sky, it's the easiest to videotape. With your camcorder mounted on a tripod, set your camcorder on the maximum wide angle setting and gently put the camcorder lens right on the eyepiece. Be very careful not to jar the telescope when you do this since even the slightest movement will knock the scope off target. Make sure you have a protective filter (UV or Sunlight) filter on your camcorder so that you don't scratch the lens. Getting the proper positioning of camcorder lens to telescope eyepiece is kind of tricky, so give yourself a few minutes to get the hang of things.

I've taken some great videos of the moon this way. Because of the earth's rotation, the moon will seem to move right out of the picture. This looks great on tape!

# Time Lapse — Interval Recording

With interval recording you can make a video where a flower blooms in seconds.

Many camcorders, especially those made by Matsushita, have a time lapse (also called interval recording) setting. This turns the camcorder on for one second every 30 or 60 seconds. Using this you can see the sun rise or set in just a few seconds. You can literally watch a flower bloom in moments. Simply place your camcorder on a tripod, focus on your subject, hit time lapse and your camcorder will do the rest.

Taking time lapse shots of such seemingly mundane things as a structure being built, a campsite being set up or even chairs being put out for an event, can be very visually entertaining. Generally speaking, if the event is something that visually evolves over the course of a several minutes or hours, it's a prime candidate for time lapse.

If your camcorder doesn't have time lapse setting, you can get the same effect by turning it on and off manually, much the same way you would while shooting an animation. However, if the event is longer than a sunrise or sunset, creating a manual time lapse sequence will be an extremely boring and tedious task.

"...see the sun rise or set in just a few seconds."

# Animation

Animation may be easier than you think. To animate an object, keep your camcorder stationary (on a tripod) and move the subject a little for each shot.

Animation can be a blast. Place your camcorder on a tripod and turn it on for one second while shooting an inanimate object such as a kitchen chair. Move the chair slightly and take another second of video. Repeat this process several times and *viola!* You have the attack of the killer kitchen chair. Thanks to the smooth transitions made possible by the flying erase heads on most camcorders, objects filmed in this way will seem to be moving on their own.

Animated scenes can add a great deal to any video. For example, you can have a child's favorite stuffed animal come to life to introduce a tape. You can animate letters to create a title for a videotape—you could use blocks, coins or other small objects to literally build the letters in a title. Using ordinary modeling clay, you could even create your own Gumby-like claymation.

Let your imagination be your guide as you have fun creating all types of animations, and don't be afraid to try your own ideas and techniques. Even though I've found that one second shots create an effective animated sequence, but you can try using two, three or more seconds. Animated sequences will be choppier, but they can still make objects seem to come alive.

"Let your imagination be your guide as you have fun creating all types of animations..."

# Video As A Hobby

Are you a collector? Most of us collect something. It could be as simple as recipes or as involved as coins, stamps or dolls. Collecting videotapes can be an extremely rewarding pastime.

You could collect videos of your children or grandchildren growing up, scenes around your town, vacations...any subject that interests you. Whatever you collect, take the time to label your videotapes. There's nothing worse than spending hours looking for one particular tape. By the time you find it, you may have forgotten why you wanted to see it in the first place.

Storing your video collectibles is tricky since videotapes are finicky. They must not get too hot or cold, too damp or dry. I store mine in the basement, which stays cool (between 55 and 70 degrees) all year long. I invested about $150 in a dehumidifier, which I keep set on medium. I also store them in dust-free, plastic videotape boxes. My tapes (some as old as 15 years) are fine. I also make sure to keep them away from any EMFs (electromagnetic fields, which can be found near fluorescent lights, speakers, or motor driven appliances).

"Collecting videotapes can be an extremely rewarding pastime."

# Romantic Video

You can blush now, but I'll bet there isn't anyone who hasn't thought of their camcorder as an excellent tool to capture private, erotic moments. You'll need a tripod, and a low lux camcorder. Frame the scene (i.e., the bed, the couch, the hot tub) and start the tape.

One of the most common mistakes most people make is positioning the camcorder so you see mostly just skin and motion (seen a lot of these, have you Steve?). It can be much nicer to see the faces of people as they enjoy this supreme state of ecstasy.

A couple of caveats here. Both parties must consent to the taping. To do this without someone's consent and knowledge is illegal. You can go to jail; it's that simple. Talk it over with your partner first.

Secondly, guard these tapes with your life! Don't use them to record a movie of the week or anything else. One glitch in your VCR, and the family could wind up watching Mommy and Daddy going hot and heavy in the middle of a soft drink commercial. Uh huh!? Use dedicated tapes and keep them under lock and key!

Video is an excellent medium for sexual role playing. It could be your ultimate titillation to watch your fantasy come to life in full color video with you and your partner as the stars.

"...capture private, erotic moments."

# Special Situations

## Bad weather, and underwater

**Cold and hot**

Your camcorder will operate efficiently in temperatures between about 30 to 100 degrees Fahrenheit. You can operate it in colder temperatures if you store the camcorder at about 40 to 50 degrees for a half hour before exposing it to keep the lens from fogging.

You'll risk freezing the motor and damaging the electronic components if you keep your camcorder in very cold conditions for more than two minutes. Even with this kind of preparation, run the unit for only one or two minutes before returning it to the warmer temperatures.

A cold weather compromise is to have the camcorder in a heated car, or keep it in the house and shoot through the open window. This way, as long as the car's heater keeps running or you don't mind paying the heating bill, you can shoot indefinitely.

Be careful in extreme heat! Above 100 degrees, the delicate electronic components in your camcorder could be permanently damaged. Again, a few minutes at the extreme is okay, but use a blanket to shield the camcorder body from the direct rays of the blazing sun.

**Rain**

A hard rain will render your autofocus system useless: your camcorder will keep trying to focus on the raindrops, so it will hunt indefinitely. In this situation, manual focus is a must.

Also, a hard driving rain can ruin the delicate electronics of your camcorder. Here again, shooting from a car or building is the best answer for keeping your camcorder dry. By and large, most videos of rainy days are gray and bleak, at best. Ask yourself why you're taking the video in the first place, especially if it's a subject that can wait for another time.

One final note of caution: Never use your camcorder in a thunderstorm. In the middle of a raging lightning storm, a pound of metal motors and gears with an active electrical charge running through it is probably the last thing I'd want in my hand. Get the picture? Lightning and camcorders don't mix!

At left, rain tricks the autofocus; at right the same scene with manual focus control.

**Underwater**

There are companies that make special housings which allow camcorders to be operated underwater. Most good ones cost $400 or more. They do a fine job, but ask yourself one question: "How often will I use this?" If you're not a scuba enthusiast, probably not that often.

Is underwater video of that one snorkeling trip to the Grand Caymans important enough to shell out $400+? You can buy a lot of filters, a great tripod or a decent video editor for that kind of money. But, if underwater footage is really important to you, don't wing it, buy the proper housing! I actually know someone who ruined his camcorder by trying to take it underwater in a clear plastic bag. You know, Murphy's law is right.

# Showing Your Videos

## Without losing your friends

Now you have this great masterpiece titled **Raiders of The Lost Barbecue**, how are you going to get your friends, neighbors and relatives to sit through it?

Edit the tape so that you're only showing the high points. (I'm sorry, but even Hitchcock would have had problems making two hours of sizzling burgers look interesting.) When you've edited down the tape to a respectable length, maybe you can mix in some music and sound effects.

On playback, be sure you show the video on a TV screen that's big enough for everyone to see. Keep the sound at a comfortable level, and serve popcorn and other "quiet" snacks (there's nothing worse than losing an important moment to a loud crunch!). Paying attention to the little things really makes watching your videos something special; it will help your viewers enjoy themselves.

Okay, sounds like you're ready. Roll 'em!

"Paying attention to the little things really makes watching your videos something special..."

# The Future of Video

I know someone who hasn't bought a camcorder yet because he is waiting for the technology to slow down. He's going to be old and gray and still not own a camcorder, because the technology is expanding almost hourly. Don't wait to get a camcorder, or memories will pass you by. The camcorder you buy today will do just as good a job as next year's New and Improved model, and, in between, you won't miss the memories.

In a few years, I feel that videotape will gradually begin to be replaced by recordable CDs. It's already happened in audio, and it's just a matter of time until recordable compact discs catch up to video. Still, the change will be gradual. If you buy a camcorder in the next year or two, by the time recordable disc units are on the market and prices come down to a reasonable level, you'll be ready for an new machine anyway.

Unlike the stereo systems of twenty or so years ago, video isn't a game of "who's got the newest, biggest and best." Home video is all about capturing memories so you can enjoy them forever. The key word is ENJOY! Keeping up with the latest technology in the video magazines is interesting and extremely helpful. Just don't let the new technology blind you to the fun you can have with your current camcorder.

"Don't wait to get a camcorder, or memories will pass you by."

# Summary

I've read studies that say the average American uses his or her camcorder less than a dozen times each year. Since you've purchased this book, you've proven yourself to be above average when it comes to interest in your camcorder. By reading this book, you are making a commitment to taking better videos, and better videos will help you maintain an interest in using your camcorder more. The best videos only come from the experience and knowledge you'll gain as you use your camcorder regularly, and that's how you'll derive the most satisfaction from your investment.

Always keep your camcorder ready to go. You never know when that once-in-a-lifetime video opportunity will come your way. I've captured many priceless moments already. I know you'll be able to say the same very soon!

Good shooting!

"Always keep
your camcorder
ready to go."

# Glossary

**AFM.** An acronym for Audio Frequency Modulation, the audio format in some 8mm camcorders. AFM sound occupies the same portion of the tape as the video signal. For this reason, you cannot dub sound on a camcorder that uses AFM sound.

**Autofocus.** An automatic, electronic method of focusing your camcorder.

**Backlight.** The light source (natural or artificial) positioned behind your subject.

**Camcorder.** A video camera and video recorder housed in one unit.

**CCD.** Acronym for Charged Coupled Device, the computer chip used in most camcorders to generate the video signal. Some newer camcorders have 3 CCDs, one each for the three primary video colors, red, green and blue.

**Crossing the line.** Shooting a scene from two completely different angles, or ignoring the 180° rule. Done without a smooth transition, it can cause your video to look disjointed and confusing.

**Depth of field.** The area in front of and behind your main subject where objects will still be in focus.

**Desktop video.** The use of computer hardware and software to edit home video.

**Digital.** A numerical, computer-based technology.

**Dubbing.** Copying a video or audio tape.

**Editing.** Assembling a logical finished tape by recording selected pieces from other tapes. This requires at least a VCR or another camcorder.

**Editing Console.** A device that assists you in the editing process. Simple editors start and stop your camcorder at the desired locations. More complex units create smoother video transitions, mix audio, and add titles and/or graphics to the edited tape.

**Editing Software.** Computer programs that allow computers to be used in the editing process.

**Eight millimeter (8mm).** The smallest camcorder format. Because of its method of recording images and sound, 8mm has better picture and audio quality than VHS or VHS-C.

**Eyeline.** The direction of your subject's gaze.

**Filters.** Pieces of optical quality glass or plastic that are placed over your camcorder's lens for protection, to enhance the color, add special effects or to reduce glare.

**Flying Erase Head.** A type of record head on a camcorder that allows smooth, seamless transitions on your tape when you start and stop a camcorder. Today, all camcorders have flying erase heads. A camcorder without a flying erase head must be at least a few years old.

**Focus.** Sharpening the clarity of you subject.

**Frame. 1.** The entire area seen in our viewfinder **2.** Placing you main subject between two objects. **3.** The measurement of a single section of videotape, usually used in professional video.

**Hi8.** A near-professional quality version of the 8mm camcorder format.

**Hunting.** An autofocus system searching before finally focusing on the main subject.

**Image Tube.** The oldest method of generating a video signal used in early consumer video cameras (with separate recorders). They were very fragile and didn't have as good a picture as later CCDs.

**Infrared.** One of the earliest autofocus systems.

**Interval Recording** (*See* **Time lapse**).

**Lead Acid.** A type of rechargeable battery that doesn't have the "memory" problems inherent in NiCad battery cells.

**Lithium/Ion.** A relatively new type of rechargeable battery which doesn't have the "memory" problems of NiCad battery cells.

**Lux.** A unit of light measurement. Most commonly, one lux equals 0.1 foot-candles (the illumination from a candle measured at one foot).

**Macro Focus.** A camcorder feature allowing you to take extreme close-up shots of small objects .

**Manual Focus.** Focusing your camcorder "by hand," without using the autofocus feature.

**MOS.** Acronym for metal oxide semiconductor. A video image chip that preceeded the CCD.

**Nickel Cadmium (NiCad).** The most common type of rechargeable battery used in camcorders. A NiCad battery should always be completely drained of power before recharging to ensure that it will always hold the maximum charge.

**PCM.** Acronym for Pulse Code Modulation, an audio format found in some 8mm and Hi8 camcorders. PCM sound allows dubbing of new audio material without erasing the existing audio or video track.

**Pan.** A horizontal movement of your camcorder meant to take a panoramic view.

**Pull.** Using your zoom lens to move "further" from your subject.

**Push.** Using your zoom lens to move "closer" to your subject.

**Rule of Thirds.** Mentally dividing your frame into equal horizontal and vertical "thirds." The inter-sections of the mentally drawn horizontal and vertical lines are the most aesthetically pleasing places to position your main subject.

**S-VHS.** A higher quality version of the VHS camcorder format.

**S-VHS-C.** A higher quality version of the VHS-C camcorder format.

**Scene.** A particular segment of videotape, usually with a specific continuity.

**Shoot.** Video slang for operating a camcorder. It is also used to refer to an entire video session.

**Shot.** Refers to the area seen in the viewfinder.

**Telephoto.** The ability of your zoom lens to bring a subject "close" to the camcorder.

**Tilt.** The vertical movement of your camcorder. The vertical version of panning.

**Time Lapse** (also called **Interval Recording**). The feature that programs a camcorder to take periodic shots of video tape automatically. Time lapse creates an almost magical view of actions like sunrises, sunsets, or blooming flowers. When scenes like this are taken with time lapse, they seem to happen in a few moments, rather than the several minutes or hours they take in reality.

**Tripod.** A three-legged device that supports and steadies your camcorder.

**TTL.** Acronym for Through The Lens, a type of auto-focus system.

**VCR.** Acronym for Video Cassette Recorder.

**VHS.** Acronym for Video Home System, the camcorder format that is compatible with most home VCRs.

**VHS-C.** A compact version of VHS. VHS-C tapes are compatible with VHS VCRs by using a playback adapter.

**Wide Angle.** The ability of your zoom lens to move a subject "away" from the camcorder.

**White Balance.** The color sensitivity of your camcorder in a particular lighting situation.

**Zoom In.** Same as Push.

**Zoom Out.** Same as Pull.

**Zoom Lens.** A lens that allows you to vary how near or far a subject will appear.

# Video Publications

Whether you're a newcomer or an experienced pro, you should read as many monthly video magazines as possible to gain understanding, tips, and pointers. I have found many of them to be extremely useful for improving my own technique as well as for keeping abreast of the latest technology. They are readily available at your local bookstore, newsstand and library. If you're really committed to your new video hobby, I strongly suggest subscribing to one or more of titles.

Here's a list of the camcorder-oriented magazines I read regularly.

Camcorder
4880 Market Street
Ventura, CA 93003

Desktop Video World
80 Elm St.
Peterborough, NH 03458

Video Magazine
Box 56293
Boulder, CO 80311- 6293

Videomaker
P.O. Box 469026
Escondido, CA 92046

Video Review
P.O. Box 57751
Boulder, CO 80322- 7751

# Appendix:

## Video accessory manufacturers

Products from manufacturers mentioned throughout the text of Basic Camcorder Guide are those I have experience with, or are reputable firms whose products have been recommended to me by other video experts and enthusiasts. For more information on these products, contact your local video/photo dealer.

### Color Enhancement Lights

Allegro, Ambico, Arkon, Aztec, Bescor, Camquip, Cool Lux, GE, Hahnel, Jasco, JVC, Lenmar, Lowel Light, Omega, Packtronics, Philips, RCA, Recoton, Reflecta, Sima, Smith-Victor, Sunpack, Velbon.

### Tripods

Allegro, Ambico, Arkon, Bescor, Bogen, Camquip, Coast, Envision, Hama, Karl Heitz, Jasco, Philips, RCA, Sima, Stitz, Sunpack, Tristar, Velbon, Visionary, Vivitar.

### Filters

Cokin, Hoya, Tiffen.

### Video Transfer Units

Ambico, Jasco, Sima, Tamron, Vivitar.

### Editing Consoles

Ambico, Azden, Canon, Jasco, JVC, Lenmar, Nady, Olympus, Panasonic, Scriptovision, Sima, Sony, Vanguard, Videonics.

### Audio Mixers

Ambico, Arkon, Azden, Nady, Sima, Vanguard.

### Desktop Video Systems and Software

*Amiga:* Commodore, Future Video, Gold Disk, JVC, Newtek, Omicron Video, Quanta, RGB Computer and Video, Zuma.

*Macintosh:* Abbate Video, Adobe, Advanced Digital Imaging, Apple, Avid Technology, Diva, Newtek, Radius, Supermac Technology.

*IBM:* Automated Business Ideas, Entropy Engineering, Epyx, Fluent Machines, Future Video, IEV, Innovision Technology, Light Source Computers, Matrox Video Products, Zuma.

### External Microphones

Allegro, Audio Technica, Azden, Beyerdynamic, Crown, Electro-Voice, Jasco, JVC, Nady, Panasonic, RCA, Sennheiser, Shure, Signet, Sima, Sony, Stanton.

# Addresses:

Abbate
14 Ross Avenue
Mills, MA 02054
(506) 376-3712

Adobe Systems
P.O. Box 7900
Mountain View, CA 94039
(415) 961-4400

Allegro
1900 N. Austin Ave.
Chicago, Il 60639
(515) 745-5140

Ambico
46-23 Crane st.
LIC, NY 11101
(718) 392-6442

Apple Computer, Inc.
20525 Mariani Ave.
MS 482
Cupertino, CA 95014
(408) 974-6553

Arkon
11627 Clark St.
Arcadia, CA 91006
(818) 358-1133

Automated Business Ideas
2706 S. Hayes St.
Arlington, VA 22202
(703) 256-2555

Avid Technologies
Technology Park
1 Park West
Tewksbury, MA 01876
(617) 221-6789

Azden Corp.
147 New Hyde Park Rd.
Franklin Square, NY 11010
(516) 328-7500

Aztec Video Products
4347 Cranwood Pkwy.
Cleveland, OH 44128
(216) 581-0880

Bescor
244 Rt. 109
Farmingdale, NY 11735
(516) 420-1717

Besslor
1600 Lower Rd.
Linden, NJ 07036
(908) 862-7999

Beyerdynamic
56 Central Ave.
Farmingdale, NY 11735
(516) 293-3200

Bogen
565 E. Crescent
Ramsey, NJ 07446
(210) 818-9500

CamQuip (Gemini)
215 Entin Rd.
Clifton, NJ 07014
(201) 471-9050

Canon
1 Canon Plaza
Lake Success, NY 11042
(516) 488-6700

Coast
200 Corporate Blvd. S.
Yonkers, NY 10701
(914) 376-1500

Commodore
1200 Wilson Dr.
West Chester, PA 19380
(215) 431-9100

Cool-Lux
5723 Auckland Ave.
Hollywood, CA 91601
(818) 761-8181

Electrovoice
600 Cecil St.
Buchanan MI 49107
(201) 695-6831

Entropy Engineering
12317 Village Sq. Terrace
Suite 202
Rockville, MD 20852
(301) 770-6886

Epyx
PO Box 8020
Redwood City, CA 94063
(415) 368-3200

Fluent Machines
1881 Worcester Rd.
Framingham, MA 01701
(508) 651-0911

Future Video
28 Argonaut
Aliso Viejo, CA 92656
(714) 770-4416

GE
5365 A-2 Robin Hood Rd.
Norfolk, VA 23513
(804) 244-3226

Gemini
215 Entin Rd.
Clifton, NJ 07014
(201) 471-9050

Gold Disk
385 Van Ness Ave.
Suite 110
Torrance, CA 90501
(310) 320-5080

Hahnel
Brandon
County Cork
Ireland
(0332) 41606/42113

Karl Heitz
3411 62nd St.
Woodside, NY 11377
(718) 565-0004

IEV
3030 S. Main St.
Suite 300
Salt Lake City, UT 84115
(801) 263-6042

InnoVision Technology
1933 Davis
Suite 238
San Leandro, CA 94577
(510) 638-8432

Jasco
311 NW 122nd St.
Oklahoma City, OK 73114
(405) 752-0710

JVC
Interstate 80 & Maple Ave.
Pinebrook, NJ 07058
(800) 247-3608

Light Source Computers
500 Drakes Landing Rd.
Greenbrae, CA 94904
(415) 461-8000

Matrix
1055 St. Regis Blvd.
Quebec, Canada
H9P 2T4
(514) 685-2630

Nady Systems
6701 Bay St.
Emeryville, CA 94608
(510) 652-2411

Newtek
215 SE 8th St.
Topeka, KS 66603
(913) 354-1146

Omicron Video
21818 Lassen St.
Unit H
Chatsworth, CA 91311
(818) 700-0742

Panasonic
1 Panasonic Way
Secaucus, NJ 07094
(201) 348-7000

Philips
PO Box 14810
Knoxville, TN 37914
(615) 521-4316

Quanta Corp.
2629 Terminal Blvd.
Mountain View, CA
(415) 967-5791

Radius Inc.
1710 Fortune Dr.
San Jose, CA 95131
(408) 434-1010

RCA Accessories
Thomson Consumer Electronics
2000 Clements Bridge Rd.
Deptford, NJ 08096
(609) 853-2335

Recoton
46-23 Crane St.
LIC, NY 11101
(718) 392-6442

RGB Computer & Video
4152 Blue Heron Blvd. W.
Riveria Beach, FL 33404
(407) 844-3348

Scriptovision
7419 Lajeunesse St.
Montreal, Quebec, Canada
H2R 2J1
(514) 271-2265

Shure Bros.
222 Hartley Ave.
Evanston, IL 60202
(708) 866-2200

SIMA
8707 Skokie Blvd.
Skokie, IL 60077
(708) 679-7462

Smith-Victor
310 N. Colfax St.
Griffith, IN 46319
(219) 924-6136

Sony Consumer Products
Sony Drive
Park Ridge, NJ 07656
(201) 930-1000

Steadicam Jr.
Cinema Products Corporation
3211 S Cienega Blvd.
Los Angeles, CA 90016
(310) 836-7991

Sunpak
300 Webro Rd.
Parsippany, NJ 07054
(201) 428-9800

Tamron Industries
99 Seaview Blvd.
Pt. Washington, NY 11050
(516) 484-8880

Vanguard
7202 W. Huron River Dr.
Dexter, MI 48130
(313) 426-3470

Velbon
PO Box 2927
Torrance, CA 90509
(310) 530-5446

Videonics Inc.
1370 Dell Ave.
Campbell, CA 95008
(408) 866-8300

Visionary Products
222 Third St.
Cambridge, MA 02142
(617) 492-0300

Vivitar Corp.
9340 DeSoto Ave.
Chatsworth, CA 91311
(818) 700-2890

Zuma Group
6733 N. Black Canyon
Hwy.
Phoenix, AZ 85105
(602) 246-4238

# Index: